I CAN DRAW **KAWAII**

STEP-BY-STEP TECHNIQUES, CUTE CHARACTERS AND EFFECTS

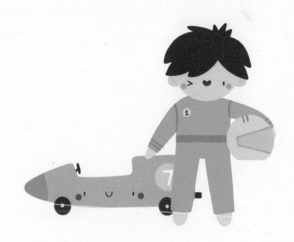

I CAN DRAW **KAWAII**

STEP-BY-STEP TECHNIQUES, CUTE CHARACTERS AND EFFECTS

TANYA EMELYANOVA

SIRIUS

SIRIUS

This edition published in 2024 by Sirius Publishing, a division of
Arcturus Publishing Limited,
26/27 Bickels Yard, 151–153 Bermondsey Street,
London SE1 3HA

ISBN: 978-1-3988-4356-1
AD012089US

Printed in China

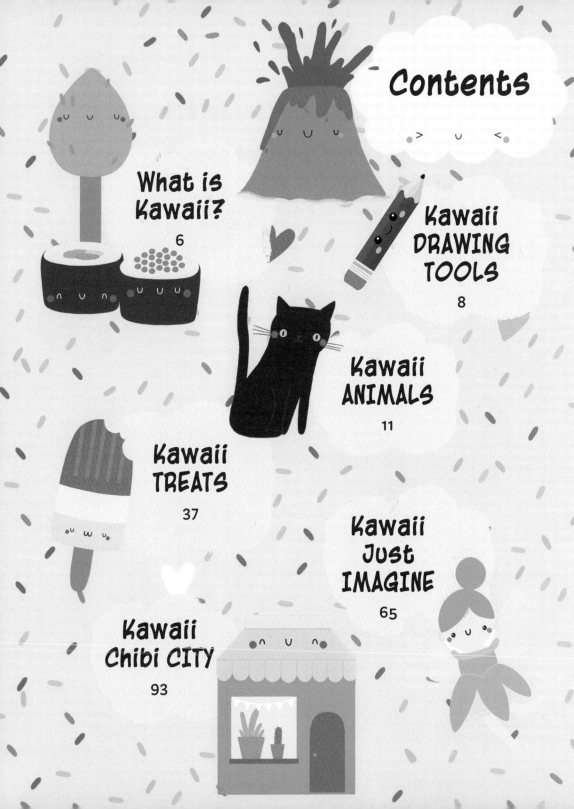

Contents

WHAT IS KAWAII?
The cutest characters

Kawaii originated in Japan during the 1970s. Initially, the word just meant "cute," but today kawaii has become a byword for a cool style of art and fashion that is popular all over the world.

Kawaii characters represent fun, cheekiness, friendship, and laughter ... but most of all, they are the definition of cuteness. This book shows you how to draw a range of kawaii characters in different settings.

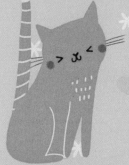

Kawaii characters are simple to draw, with large round heads, dots for eyes, tiny noses, and smiles, most rendered in soft colors or pastel shades.

You can add a kawaii face to just about anything you want including trees, clouds, and a huge variety of food, from fruit and vegetables to cakes, pizzas, and burgers.

Drawing kawaii

You can draw kawaii with any kind of pencils or pens, but we suggest drawing a light pencil outline, then going over it with your choice of drawing material to match the shades you want.

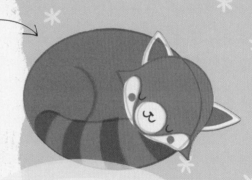

DRAWING TOOLS

You don't need lots of expensive equipment to start creating your own kawaii art. The most important tool is your own imagination! However, there are a few key items that you might like to get to start you off, depending on the medium that you choose for your illustrations.

PAPER

Use plain **letter paper** from a stationery shop for practice sketches. **Cartridge paper** is heavy-duty, quality drawing paper, ideal for the final versions of your drawings. **Watercolor paper** is made from cotton, and is of higher quality than wood-based papers. **Line art paper** When practicing black and white ink drawing, smooth line art paper enables you to produce a nice clear crisp line.

PENCILS

Get a good range of graphite (lead) pencils ranging from soft (6B) to hard (6H). Hard lead lasts longer and leaves less graphite on the paper. 2H pencils are a good medium range to start out with until you find your favorite.

RULERS

Once you're creating whole pages, you may want to use a ruler to plan out your space.

COLOR PENCILS

You can color your kawaii sketches with pens or colored pencils. Start with a smaller range and graduate to more shades once you are comfortable with using these kind of pencils.

CRAYONS AND MARKERS

Wax crayons come in a huge range of colors and can be used in various ways, including with water. Marker pens give a clean finish and you can use different parts of the tip to vary the weight and intensity of the line.

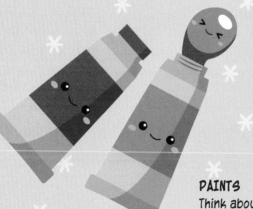

PAINTS

Think about the effect you are aiming at and choose the most appropriate medium. You can use watercolor, acrylic, and gouache paints to create your kawaii art.

KAWAII FACES

Most kawaii faces use the simplest of marks—dots or lines for eyes, a curve for a mouth and rosy cheeks—to create a character's personality.

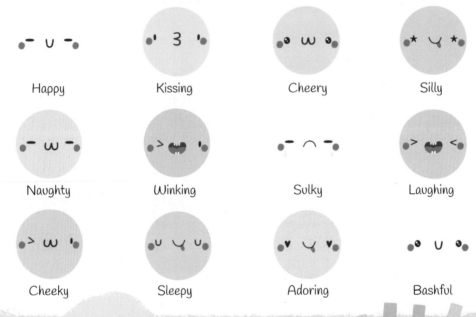

Here are some different faces you can use on your kawaii characters to show different moods and personalities.

Happy

Kissing

Cheery

Silly

Naughty

Winking

Sulky

Laughing

Cheeky

Sleepy

Adoring

Bashful

For extra cuteness, draw large dark eyes with white dots for reflections, plus rosy cheeks.

You can add other details to the faces, then decorate with hearts and stars, but keep it simple.

Follow the steps in this book, copy the drawings into the scenes, then invent your own delightful kawaii characters.

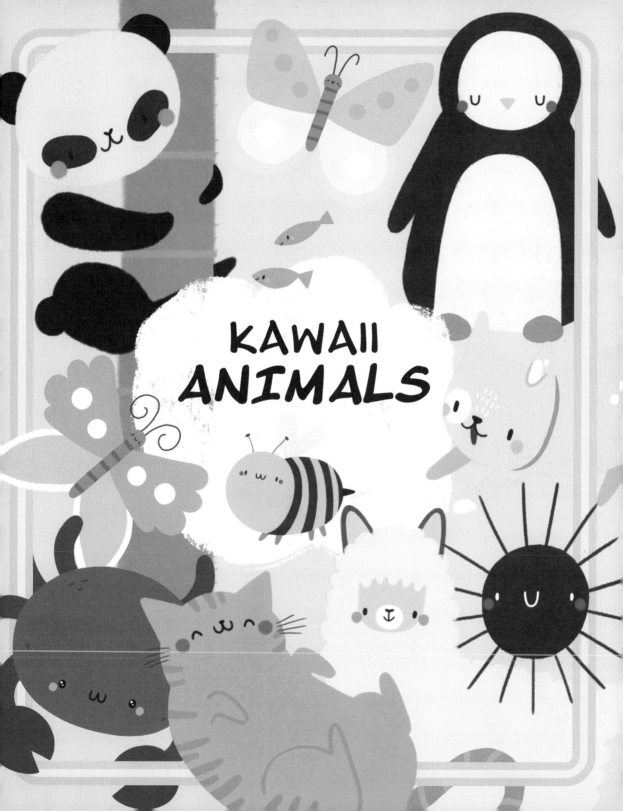

KAWAII ANIMALS

KAWAII KITTEN

Most kawaii cats start with just one outline which will vary depending on whether you want it to be lying, crouching or sitting up.

1. Draw an outline that looks a bit like a broad bean.

2. Then add in the fore legs and the hind legs.

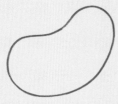

3. Draw the ears and the tail.

4. Erase the outlines that you don't want to show on your finished drawing and fill in with your chosen color. Add details such as rosy cheeks and whiskers.

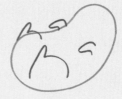

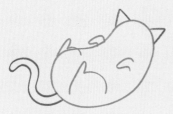

Colorful kitties

Try giving each of your cats a different body shape, facial expression, and fur pattern.

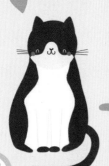

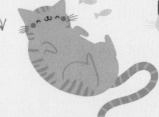

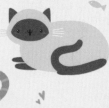

KITTENS PLAYROOM

We've created a background to which you can add
your own playful kawaii kittens …

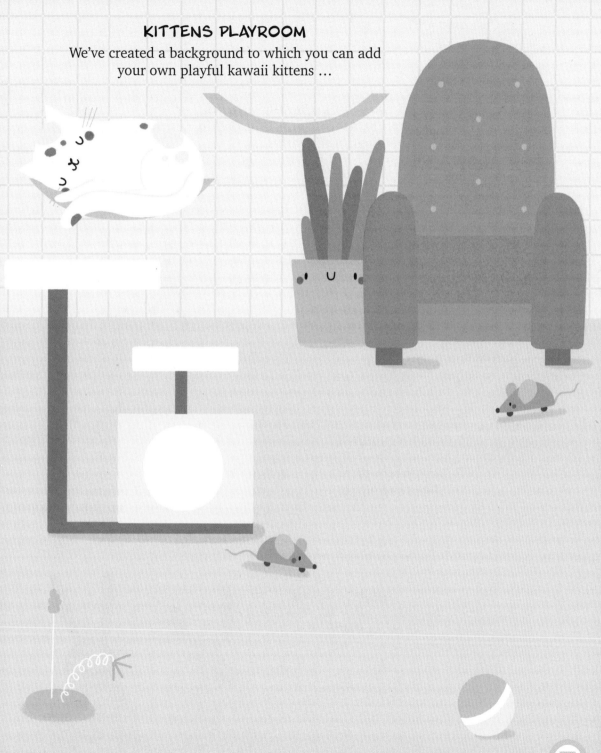

KAWAII BUNNY

This little rabbit is created using just a few simple shapes. You can vary the pose simply by adjusting the relationship between the circles and the shape of the ears.

1. To make the head, draw a circle lightly in pencil.

2. Then add the main part of the body and the ears.

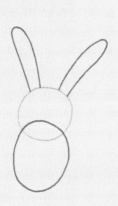

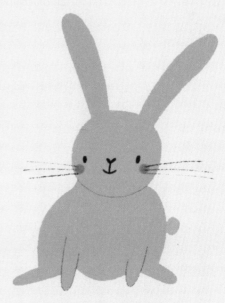

3. Draw in both sets of legs and the tail.

4. Erase the outlines that you don't want to show on your finished drawing and fill in with your chosen color. Add details like rosy cheeks and whiskers.

Rabbits Galore
Vary the ear position and colors to create a variety of different rabbits.

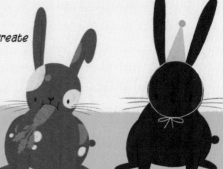

DRAW YOUR OWN RABBITS ON THIS VEGETABLE PATCH

We've created a background to which you can add your own rabbits.
Try to make them as varied as possible.

turnip

carrot

cabbage

radish

15

KAWAII PANDA

Because this cheerful panda is clutching a bamboo stem, it uses more initial shapes than the kitten and rabbit pictured earlier.

1. Draw a circle for the head. It can be slightly flattened if you want a different shape.

2. Add in the ears, which should be rounded, and a long, tilted oblong for the bamboo stem.

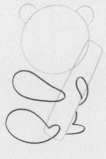

3. Now draw in the arms and legs. Remember that you'll need to show how the panda is holding the bamboo.

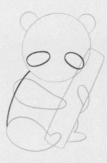

4. At this point draw a line for the back, and place the eye patches.

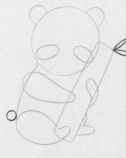

5. A couple of leaves complete the bamboo stem, while a tail is the final touch on the panda's outline.

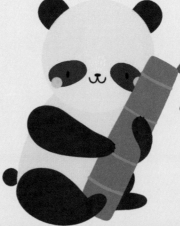

6. You can now color your panda and add facial features and a cute expresson.

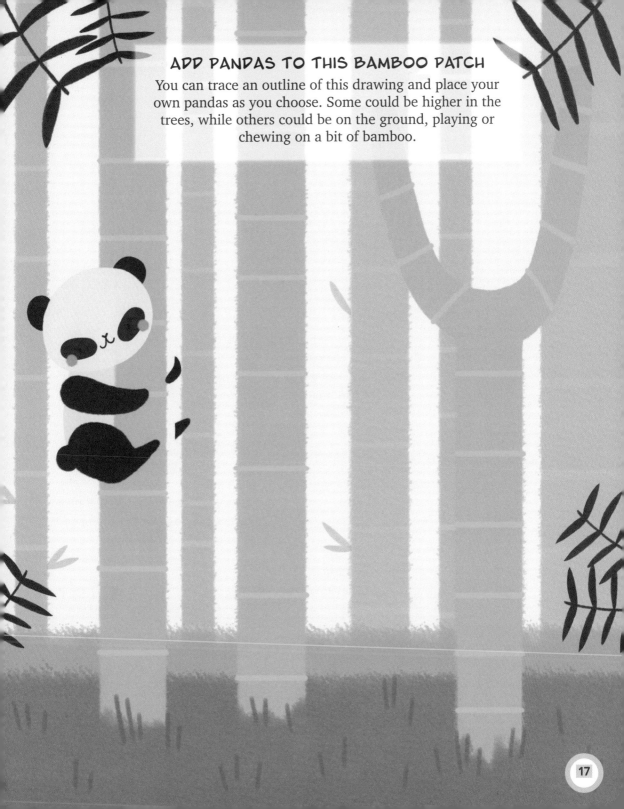

ADD PANDAS TO THIS BAMBOO PATCH

You can trace an outline of this drawing and place your own pandas as you choose. Some could be higher in the trees, while others could be on the ground, playing or chewing on a bit of bamboo.

KAWAII PUPPY

The puppy shown here is based on the shiba inu, a small and muscular breed of Japanese hunting dog. The drawing uses a combination of the techniques shown earlier.

1. Draw a circle for the head. You can make it taller or wider if you like.

2. Now put in the ears—note that they merge into the head—and a bean-shaped body.

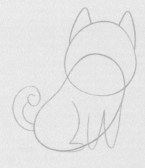

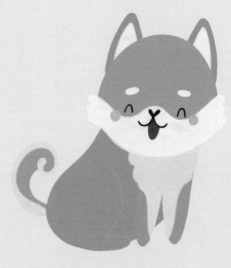

3. The curly tail and fore and hind legs are sketched in at this stage.

4. Color in your puppy, adding cute facial features and a cheerful smile. You can add a tongue if you like.

Best in show!

Give each dog its own accessory such as a collar, bow, or scarf.

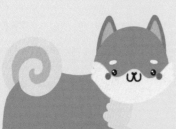

TAKE YOUR PUPPY TO THE PARK

You can trace this background and use it to add in a variety of canine companions for your puppy. Study other dog breeds to work out how you could draw them in a kawaii style.

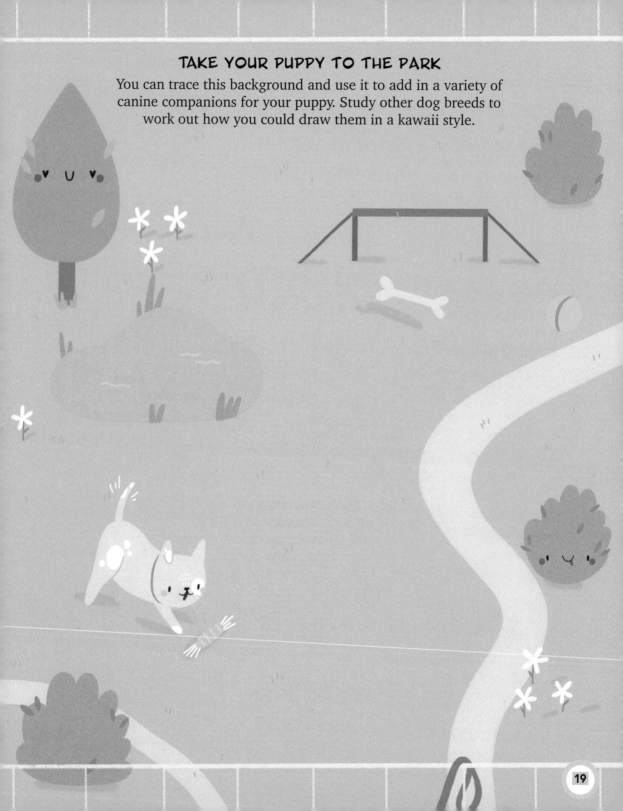

KAWAII DUCK

The instructions for this happy duck will provide a basis for a number of other kawaii birds. You'll just need to vary the size and shape of the wings, bill, and feet.

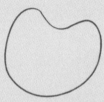

1. Draw the body first. It's a deeper bean shape than used prevously

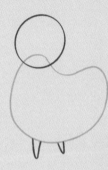

2. The head is a circle, while the feet are two short points at this stage.

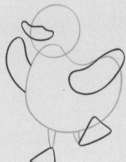

3. Now add the bill, wings and feet. You can refine the foot shape.

4. Erase the outlines you don't want to show on your finished drawing and fill in with your chosen colors. Smiling eyes and rosy cheeks add extra charm.

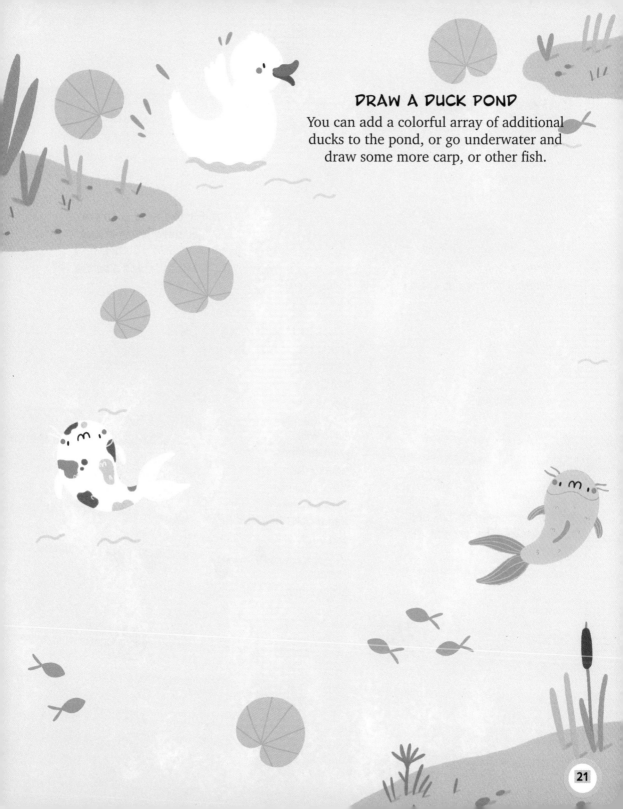

DRAW A DUCK POND

You can add a colorful array of additional ducks to the pond, or go underwater and draw some more carp, or other fish.

KAWAII LLAMA

This delightful llama is bursting with the joys of spring. You need just a few simple shapes to create his expressive body.

1. Draw a long oval shape, very slightly tapered at the end.

2. For the head and neck, you need another long oval, this time drawn vertically. Add a bobble for a tail.

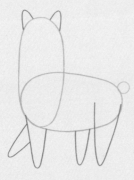

3. Add the ears, tail and four long, tapered legs.

4. Erase the outlines you don't want on your finished drawing and fill in with your chosen color. Add wavy outlines to show the wooly coat and decide on the facial expression.

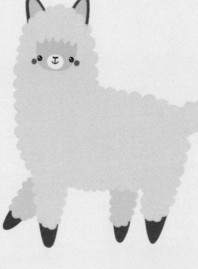

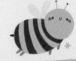

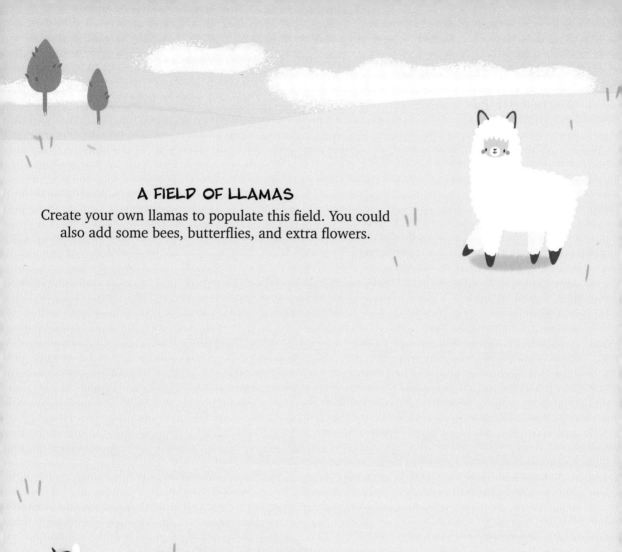

A FIELD OF LLAMAS

Create your own llamas to populate this field. You could also add some bees, butterflies, and extra flowers.

KAWAII RED PANDA

The genuinely adorable red or lesser panda is a perfect subject for kawaii. The one shown here is tucked up neatly for sleep—this is a good guide for drawing other sleeping animals.

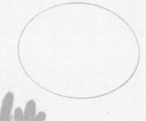

1. To start, draw a slightly elongated circle.

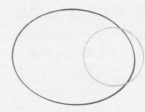

2. Draw a smaller circle, slightly overlapping the first, for the head.

3. Add in the ears, the outline of the longer fur at the side of the face, and the tail.

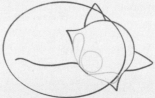

4. Firm up the shapes you have just drawn and add the white areas for the nose and cheeks.

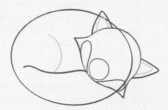

5. Add the haunch and the insides of the ears.

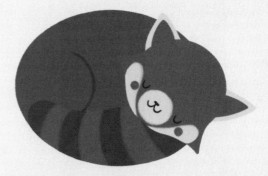

6. Now fill in with color, adding stripes for the tail and sleepy eyes.

RED PANDA AND FRIENDS
Draw in some extra red pandas in a variety of poses.

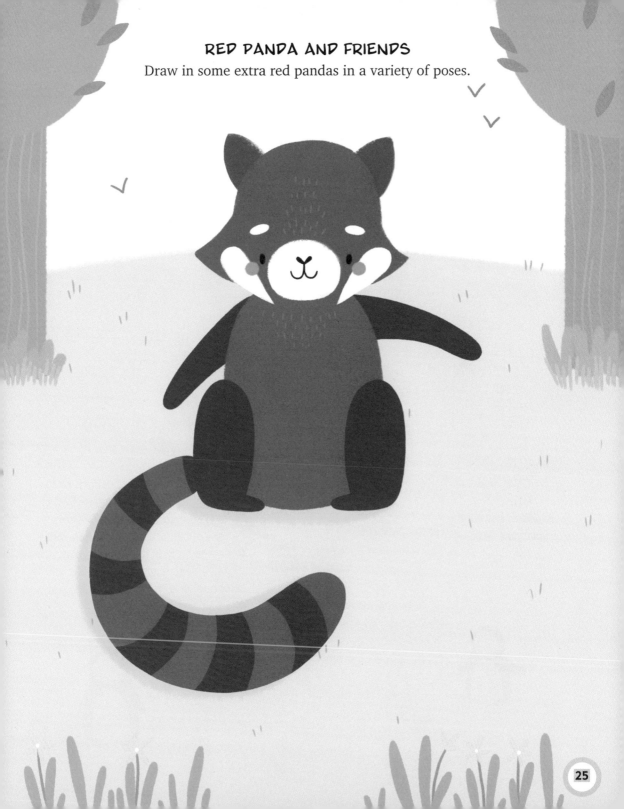

KAWAII PENGUIN

Just making tiny changes in the shape or position of your initial outline shapes can give kawaii figures like this cheeky penguin an entirely different character.

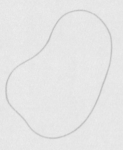

1. Draw a modified bean shape at a 45 degree angle.

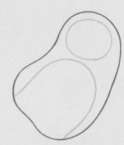

2. The face and belly are drawn inside the initial shape.

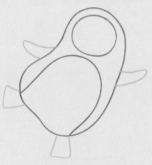

3. Add in the wings and the feet

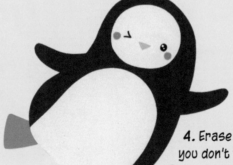

4. Erase the outlines that you don't want on your finished drawing and fill in the outer areas with black, the face and belly in cream or white, and the feet in orange. Create expression with a cheeky wink.

Winter wear

You could make scarves and hats to keep your penguins warm.

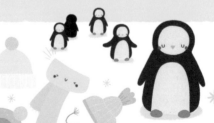

A PENGUIN PARADISE

Penguins are rarely solitary birds—in fact they gather in their thousands—so add in lots of companions for your kawaii penguin.

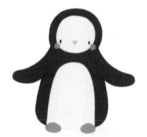

KAWAII HAMSTER

Endlessly busy and playful, hamsters are hugely popular tiny pets. You can show them running on wheels, gathering food and sleeping as well as being generally cute like the little guy below.

1. First draw an elongated oval shape for the body.

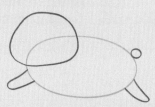

2. Then add the head, tail and "behind" legs.

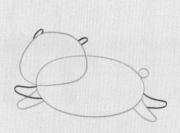

3. Ears and the second set of legs complete the outline shape.

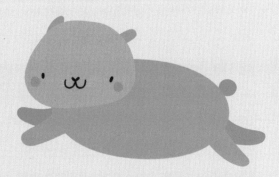

4. Erase the outlines that you don't want on your finished drawing and fill in with a golden beige color. Add details like rosy cheeks and a smile.

Cute Food

Draw some kawaii food for your hamster to eat.

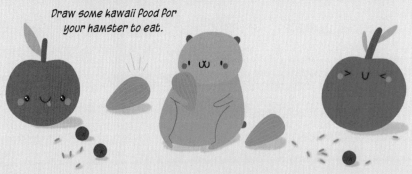

HAMSTER DEN

Draw in some hamsters in a range of poses.

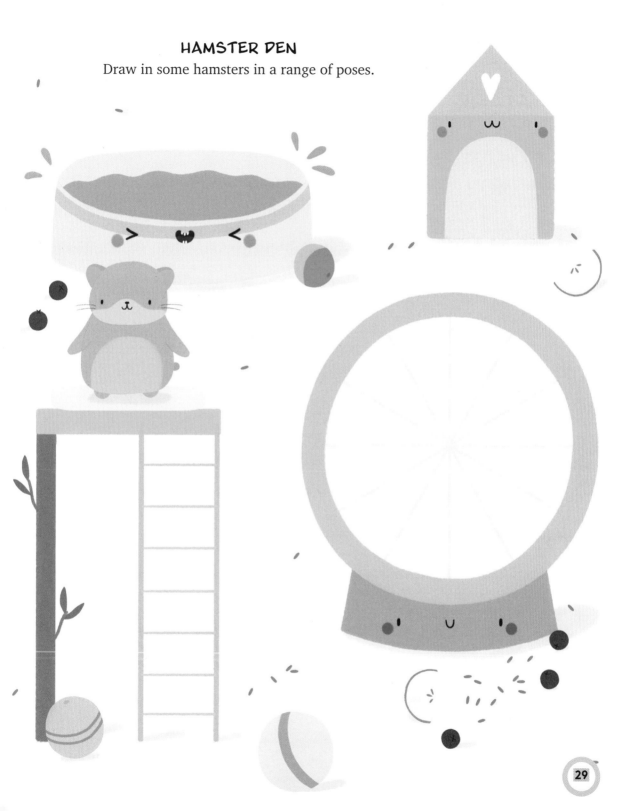

KAWAII SEAL

With their sinuous shape, seals are designed for swimming. This smiling seal uses slightly different shapes to the animals on the preceding pages to give a smooth, slinky outline.

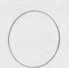

1. Draw a circle for the head.

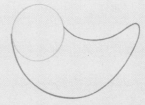

2. The seal body is a sort of "half banana" shape.

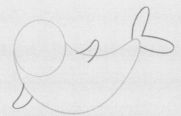

3. Add the flippers and the tail and the outline of the lighter belly (not shown here).

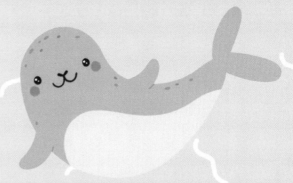

4. Erase any outlines you no longer need and fill the upper body with grey and the odd speckle. The belly should be a lighter color. Add a smile and rosy cheeks.

UNDER THE SEA

Draw in some more seals to keep this one
company, as well as a few more fish.

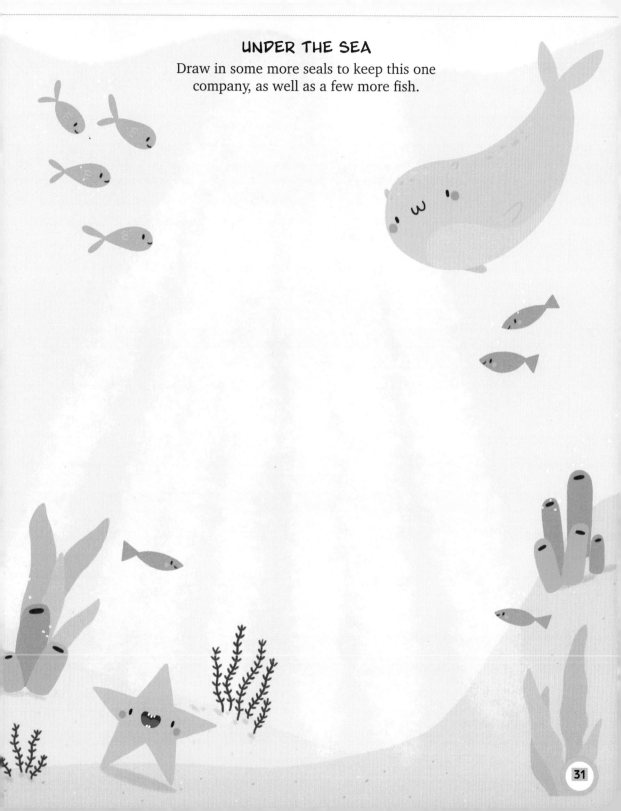

PRACTICE

Use the following gridded pages to practice
drawing your own kawaii creations.

PRACTICE

PRACTICE

PRACTICE

PRACTICE

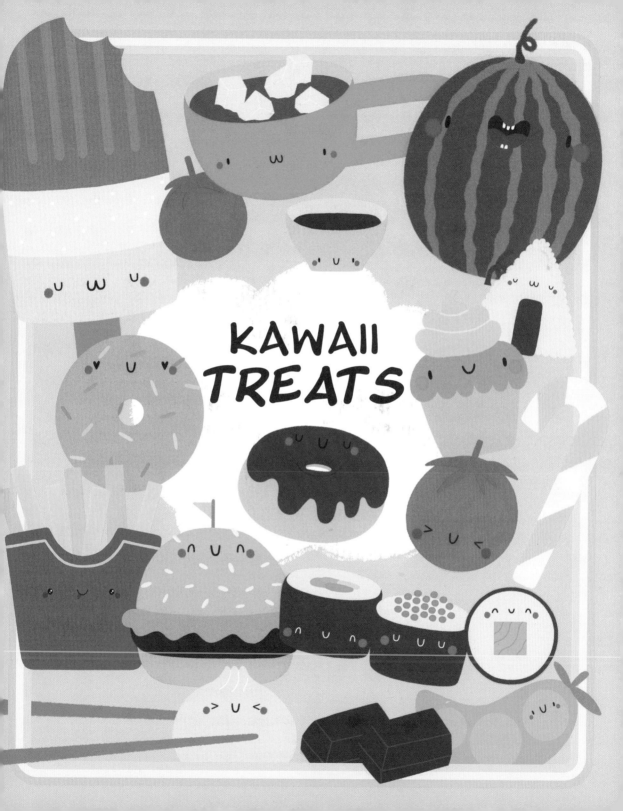

KAWAII
TREATS

KAWAII CUPCAKES

You can make a kawaii version of almost anything. Here it is a luscious, buttercream-topped cupcake with added personality.

1. Draw the outline of the cup, making it slightly wider at the top.

2. Now draw the first two layers of buttercream.

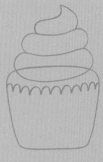

3. The final twirl and the outline of the cupcake case are last.

4. Erase the outlines you don't want to show and fill in with your chosen colors. Add colored sprinkles, rosy cheeks, and a cute smile.

Cake decoration
You can add all kinds of toppings to your cupcake.

A WINDOW OF KAWAII CAKES
Create your own cakes to fill this bake shop window.

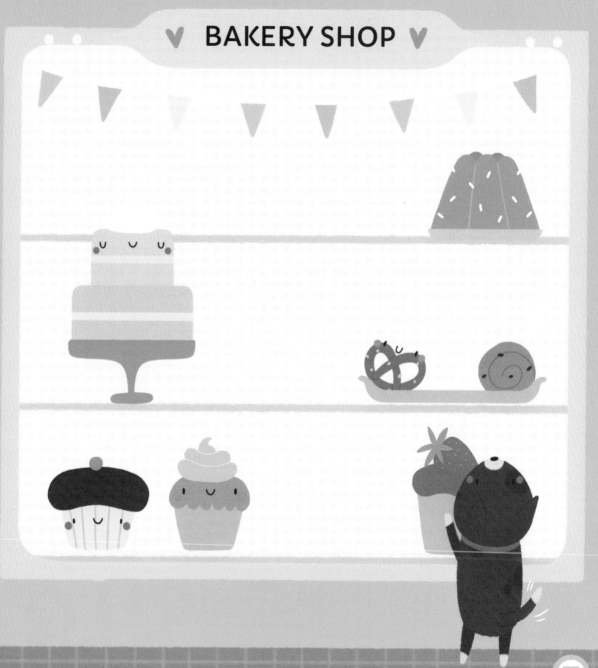

BAKERY SHOP

KAWAII ICE CREAM

Ice creams come in so many different guises that they are a delight to turn into kawaii treats. Add sauces, fruits, sprinkles, and happy faces for extra zest and charm.

1. Draw the cone as an elongated triangle.

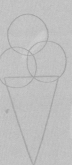

2. Add three ovelapping circles for the scoops of ice cream

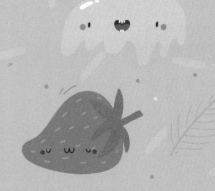

Even sweeter

Here are some tasty toppings you can add.

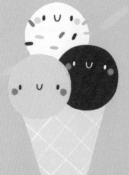

3. Erase the lines you don't want to show and fill in with the ice cream and the cone. A lattice pattern will add interest to the cone.

CHILLY CHOICES

Fill up this van with sorbets, glacés, and lollies.

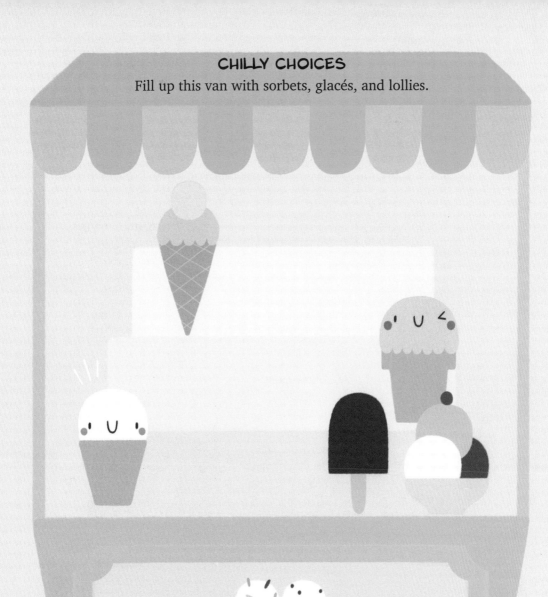

KAWAII HOT COCOA

There's nothing better than a cup of perfectly made hot cocoa to warm you on a cold day. Here's how to make a kawaii cocoa—and you can apply the technique to any drink in a cup.

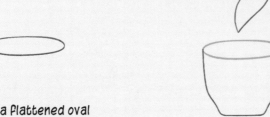

1. Draw a flattened oval for the top of the cup.

2. Now draw the main cup shape and a wisp of steam.

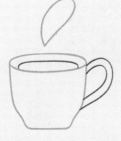

3. Add the outline of the drink and the cup handle.

4. Erase the outlines don't want on your finished drawing and fill in with your chosen colors. Give your cup a happy smile and red cheeks.

A little extra

If you need something even sweeter, add cream or marshmallows!.

DELIGHTFUL WARMING BEVERAGES

Make the waitress lots of wonderful hot drinks to fill up her tray.

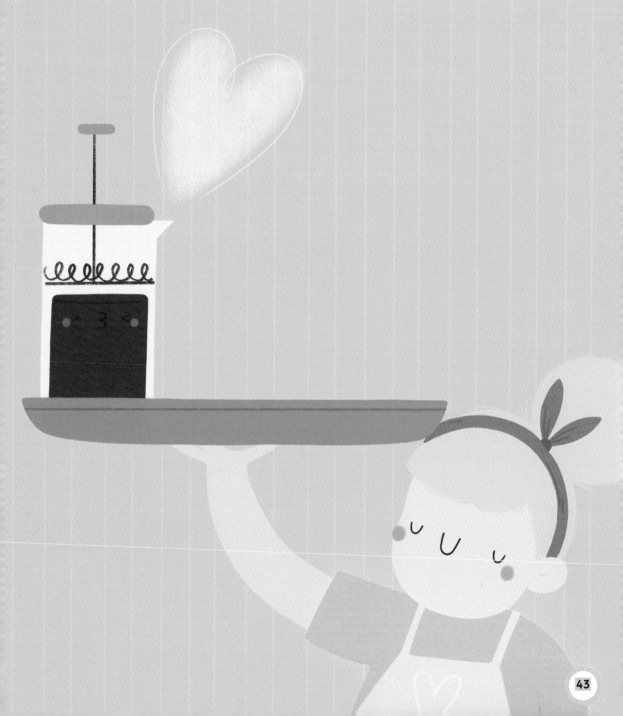

KAWAII ICED DONUTS

Possibly the ultimate decadent sweet indulgence, donuts come in many guises: simple rings, jam and custard-filled delights, and luxurious and elaborately iced. Perfect for a kawaii character.

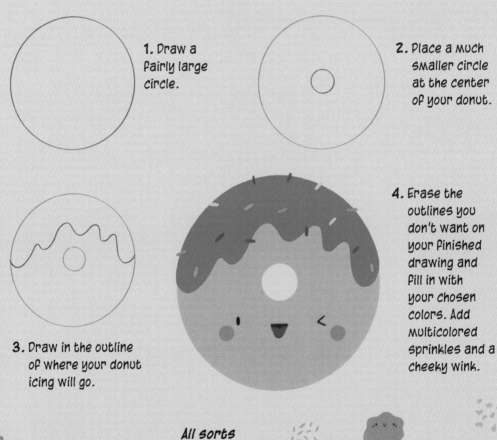

1. Draw a fairly large circle.

2. Place a much smaller circle at the center of your donut.

3. Draw in the outline of where your donut icing will go.

4. Erase the outlines you don't want on your finished drawing and fill in with your chosen colors. Add multicolored sprinkles and a cheeky wink.

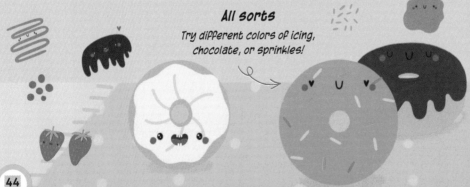

All sorts
Try different colors of icing, chocolate, or sprinkles!

A BOX FULL OF TREATS

Draw lots of glorious donuts to fill up the box.

KAWAII PINEAPPLE

With their distinctive shape, textured skin and spiky leaves, pineapples are characterful fruits, even without kawaii styling.

1. Draw an elongated oval for the body of the pineapple.

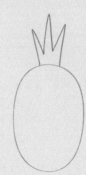

2. Add the background layer of leaves.

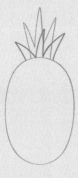

3. Then draw the leaves that appear in the foreground.

4. Erase the outlines you don't want on the finished drawing. Draw in criss-cross wavy lines to indicate the pineapple skin texture and color the rest of the fruit. Add a face of your choice.

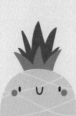

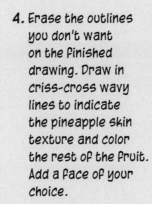

Slice your pineapple
Try drawing the pineapple in different ways.

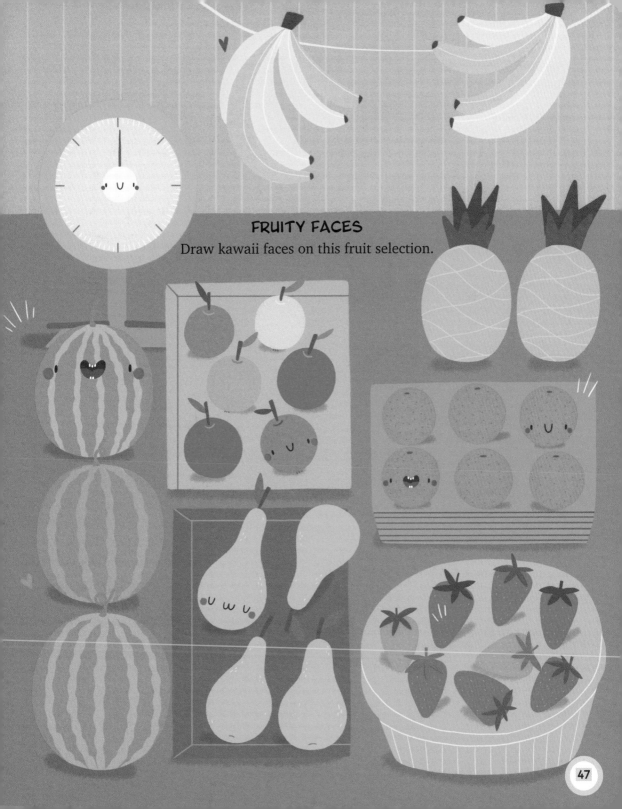

FRUITY FACES

Draw kawaii faces on this fruit selection.

KAWAII STEAMED DUMPLINGS

The Japanese dumplings known as *nikuman* are usually filled with minced pork, shiitake mushrooms, and cabbage, although a variety of other fillings can be used. They are perfect for kawaii.

1. To make the head, draw a slightly flattened circle.

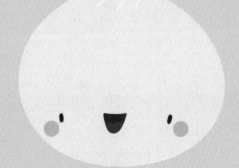

2. Draw in the top of the dumpling where the dough is pleated together.

3. Erase the outlines you don't want on your finished drawing and fill in with your chosen color. Show the pleating with white lines drawn over the main color and add facial details.

A PLATE OF NIKUMAN

Fill the plate with your own dumplings with different expressions.

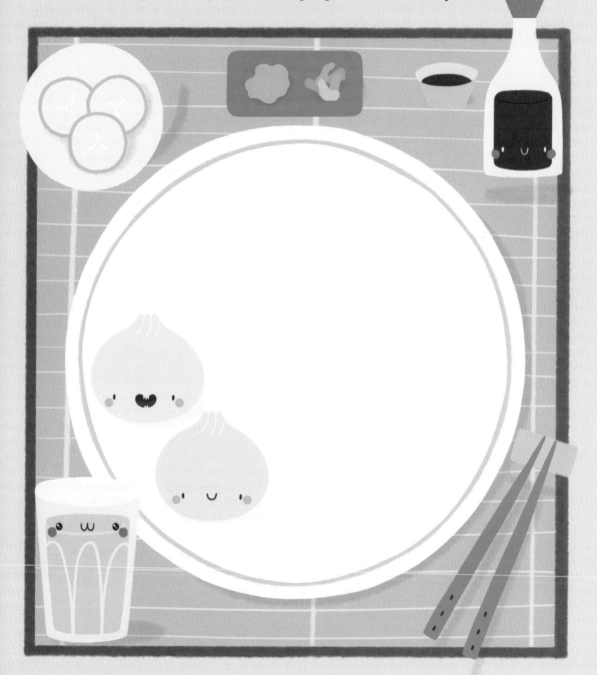

KAWAII PEAS IN A POD

The varied shapes, colors, and textures of vegetables make them a great subject for kawaii. Here we've chosen the cutest peas in a pod to render in their own special cute version.

1. Start with an elongated bean shape for the pod.

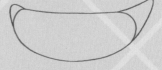

2. Draw in pointed ends to make it into more of a pea pod.

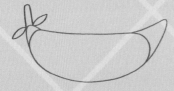

3. Next, draw the stem and leaves.

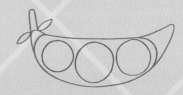

4. Add three circles of various sizes for the peas.

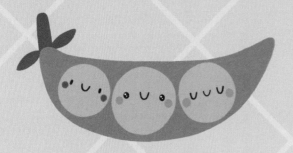

6. Remove your initial marks and add color to your drawing. You can vary the expressions of the peas in the pod if you like.

Veggie pals

Here are some different faces you can add to the vegetables.

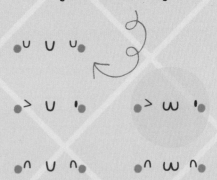

VEGETABLE BASKET

Add your own kawaii faces to these vegetables.

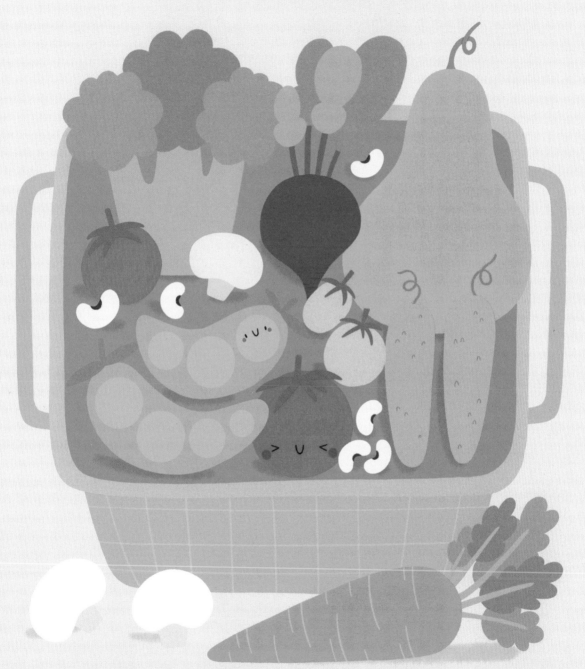

KAWAII STICKY SUSHI

Once just a Japanese delicacy, sushi, based primarily on raw fish, sticky rice, and seaweed, has become a healthy food phenomenon throughout the world. Here's how to make a kawaii sushi portion.

2. Now make a long egg shape for the body of the fish.

1. Draw an oval shape for the sticky rice.

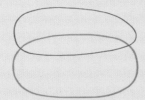

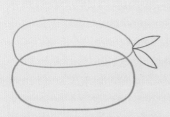

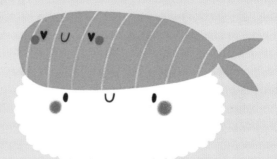

3. Give the fish a small tail.

4. Remove your working marks and color your drawing. The rice should have a scalloped outline to convey its texture. You can add white, slightly angled lines to the fish to give the impression of salmon.

Perfect parcels

Here are some other types of sushi you can add to the menu!

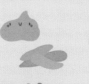

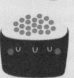

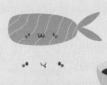

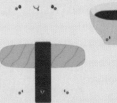

MAKE YOUR OWN SUSHI

Create different kinds of sushi to make a meal of it.

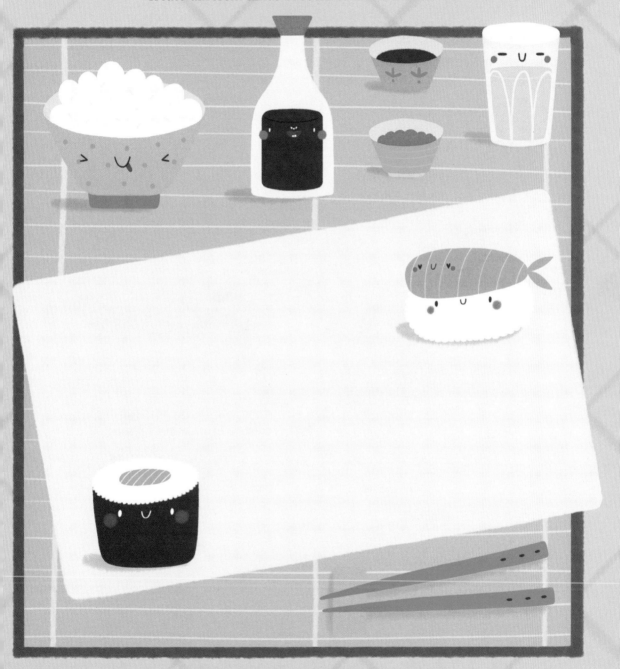

KAWAII BURGER

One of the most popular fast meals everywhere, the beef burger has evolved from a simple patty in a bun to a worldwide phenomenon, complete with ever-changing fillings.

1. Draw the outline of the whole bun first.

2. Add in the detail of where the lettuce goes.

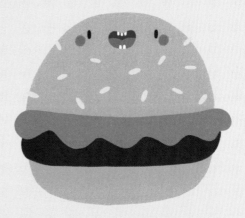

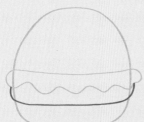

3. Draw the line of the burger.

4. Remove the outlines you don't want to show on the finished drawing and fill in with your chosen colors. We've added sesame seeds and a happy, toothy smile to the top of the bun.

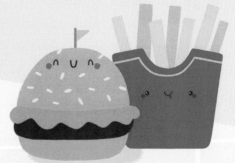

BURGER BAR

Draw some burgers with different fillings and extra milkshakes.

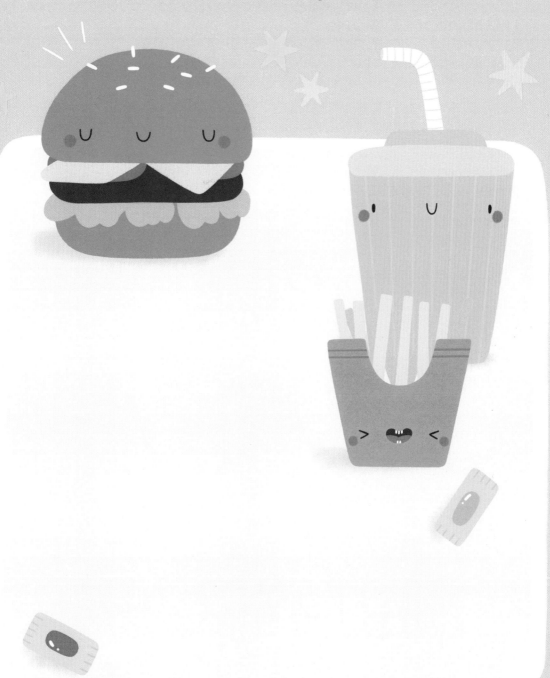

KAWAII NOODLE BOWL

Noodles are a delicious staple of east Asian and south-east Asian cooking. They are quick to prepare and go beautifully with all kinds of ingredients, including meat, fish, and vegetables.

1. First make the outline of the noodle bowl.

2. Draw in the shape of the piled up noodles.

3. Add chopsticks and the base of the bowl.

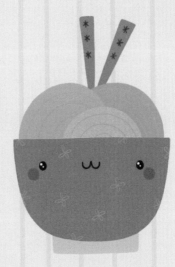

4. Erase the outlines you don't want on your finished drawing and fill in with your chosen colors. Add some detail to the chopsticks and a happy face.

Chef's choice

Add whatever you like to your noodle dishes. Here are some ideas.

OODLES OF NOODLES

Draw a selection of delicous noodle bowls to fill the empty table.

PRACTICE

Use the following gridded pages to practice
drawing your own kawaii creations.

PRACTICE

PRACTICE

PRACTICE

PRACTICE

PRACTICE

KAWAII DANCING UNICORN

One of the most popular of fantasy animals, unicorns are famous for their graceful stance and single horn. In some legends the unicorn uses its horn for healing and purification.

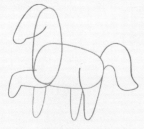

1. Create the body using a slightly angled oval shape.

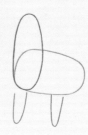

2. Add the neck and one set of legs.

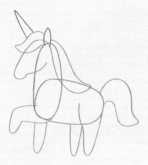

3. Sketch in the head, the near legs—one slightly raised—and a jaunty tail.

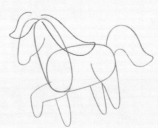

4. Give your unicorn a luxuriant mane.

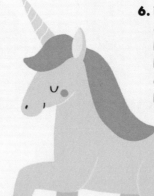

6. Rub out any outlines you don't want to show on the final drawing. As it is a fantasy animal, you can choose any colors you like for the coat, mane, and tail.

5. Finally, sketch in the all-important horn.

RAINBOW CLOUD

Draw in some more unicorns and other fantasy creatures.

KAWAII FLOWER FAIRY

You just need a few very simple shapes to draw this endearing flower fairy. You can color her hair, dress, and wings to reflect your favorite flowers.

1. Draw a circle for the head.

2. Add a small circle for her hair bun and a slightly larger one for the body.

Fairyland Faces

Here are some faces you can add to your fairies.

3. Now draw the arms and the petals of the skirt.

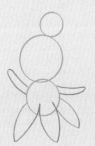

4. The line of the hair, the collar of the dress, and the underskirt are next.

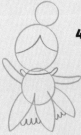

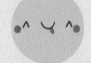

5. Finally add the wings and legs—in whatever position you choose.

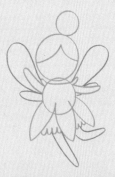

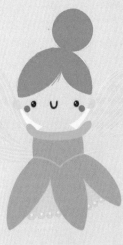

6. Remove any lines no longer needed and colour your fairy in the chosen color scheme. Add a happy smile and rosy cheeks.

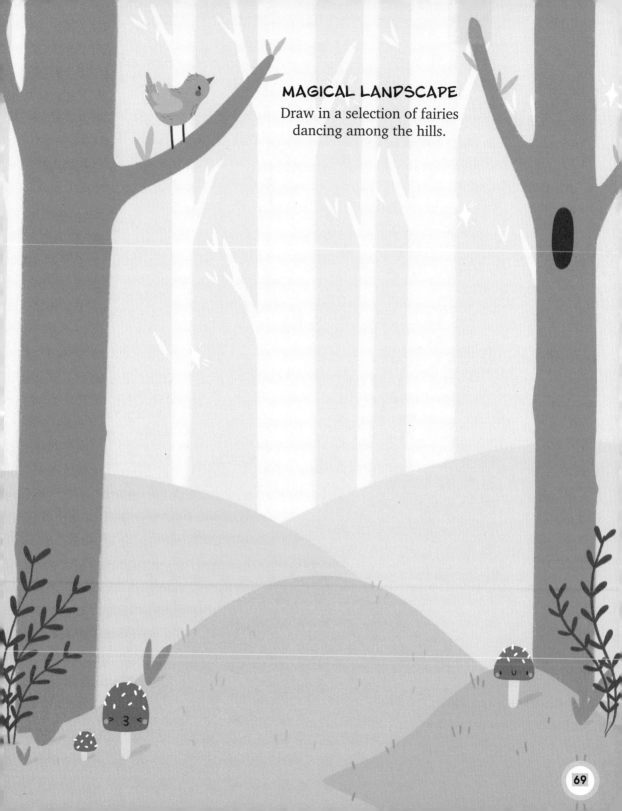

MAGICAL LANDSCAPE

Draw in a selection of fairies
dancing among the hills.

KAWAII BABY DRAGON

He's breathing fire but is not really very scary. This tiny dragon is presented in sideways view so there's a slightly different technique to drawing him. Just add wings and a burst of flames.

1. Draw a circle for the head.

2. The body is an egg shape placed slightly over the head. Draw the shape of the ears.

3. Add the horns, the shape of the nose and mouth, front leg, and a pointed tail.

4. Draw in the fiery breath and the dragon's wings.

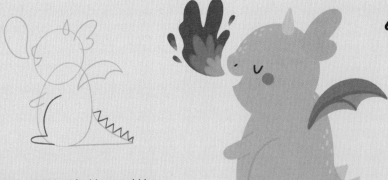

5. Finally add the hind leg and the spikes on the dragon's tail.

6. Erase unwanted lines and fill in with the colors of your choice. Your dragon can be any colour you like. Add the odd spot of texure too.

TREASURE TROVE

Draw some more baby dragons to
defend this hoard of treasure.

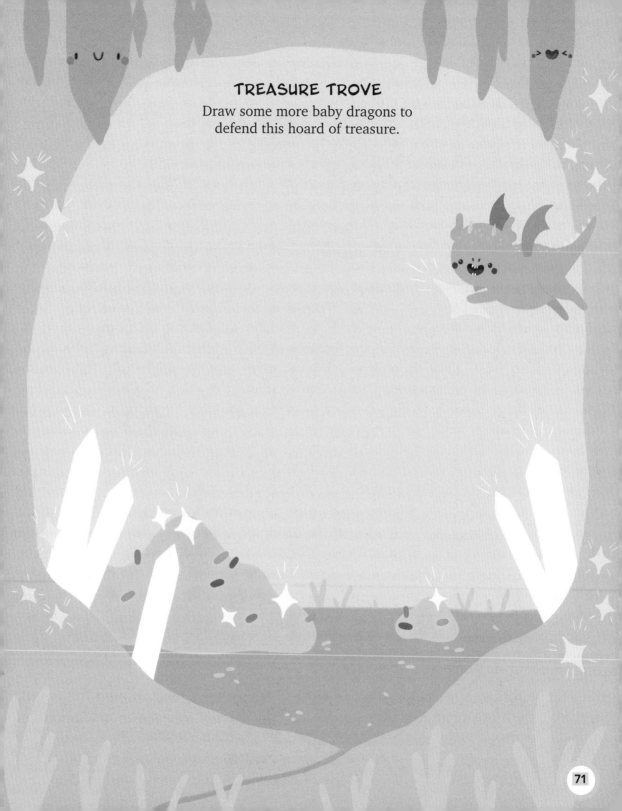

KAWAII KINDLY WITCH

This friendly witch is most certainly not the wicked witch of the west. She rides her broomstick cheerfully, accompanied by her faithful familiar—a big black cat.

1. Draw the head as a circle.

2. Now add the star at the tip of the wand and the upper body.

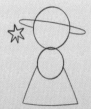

3. Draw in the ring of the hat brim and the witch's skirt.

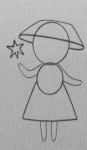

4. Now add the top of the brim, the arms, and the legs.

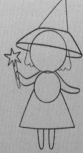

5. Finally draw the pointy tip of the hat, the hair, and the stem of the wand.

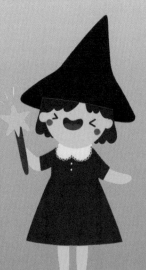

6. Remove any unwanted lines and fill in with your chosen colors. Gve the witch a cheerful expression.

Hey, presto!
Make your witches more magical with these spooky extras.

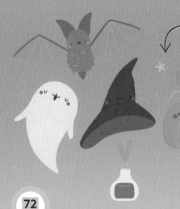

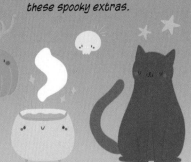

BROOMSTICKS!

Draw in a witch and her familiar
on each of these broomsticks.

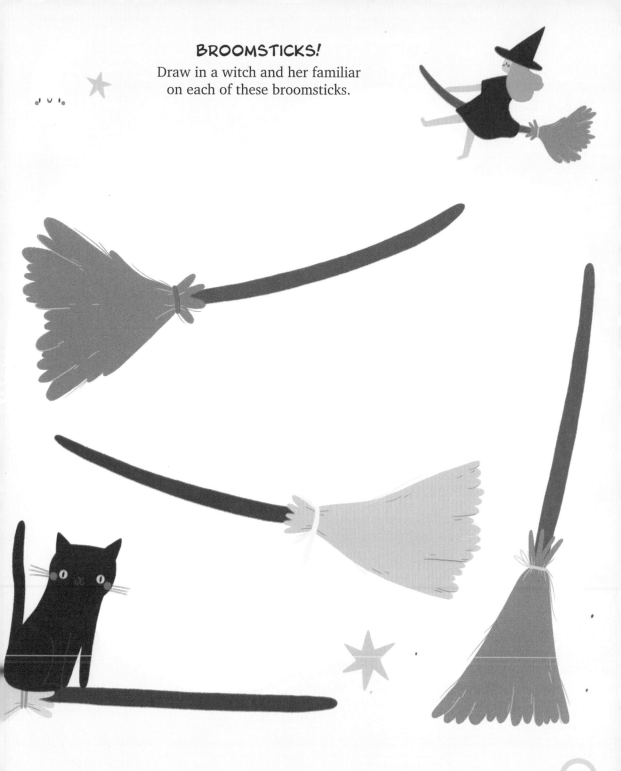

KAWAII TINY DINOSAUR

Baby dinosaurs are a great subject for kawaii art with their rounded bodies and large heads. You don't need to be super-realistic—use your imagination to make your own dino.

1. Draw a circle for the head.

2. The body should be a larger circle—how large depends on the kind of dinosaur you're aiming at.

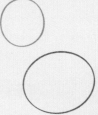

3. Add the neck and a pointed tail and a couple of tiny ears.

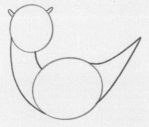

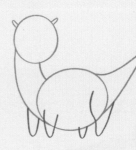

4. Now draw in the legs. These have very tapered ends but they can be squarer like the dino opposite.

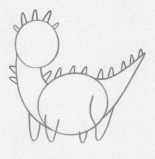

5. To finish off, give this little dino lots of mini spines. They can be as small or large as you like.

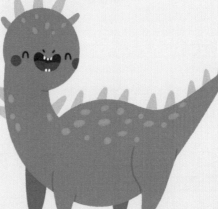

6. Remove your working lines and color your baby dino. This one has laughing eyes and mouth and lighter spots on its back.

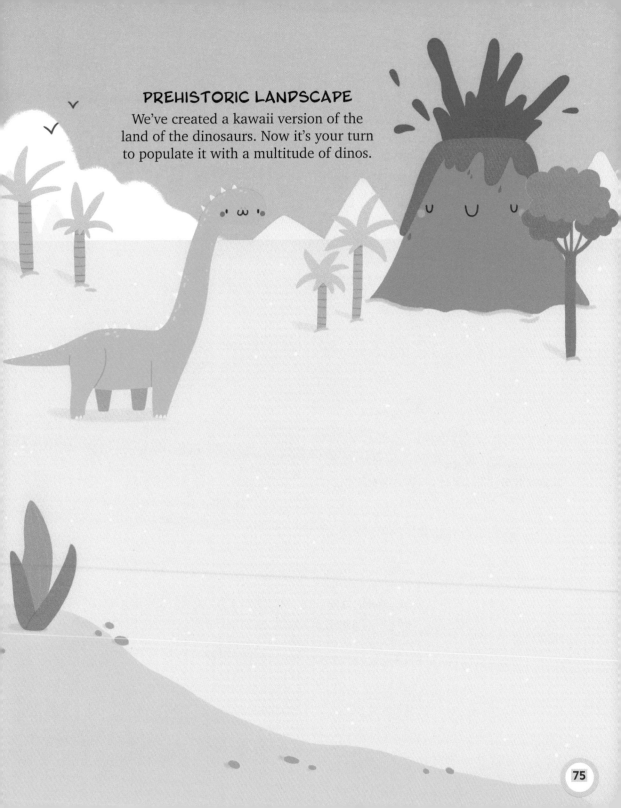

PREHISTORIC LANDSCAPE

We've created a kawaii version of the land of the dinosaurs. Now it's your turn to populate it with a multitude of dinos.

KAWAII DANCING PRINCESS

The shapes used to draw a little princess can be adapted for a huge range of fairy or period figures. Just a tweak of the hair or the costume will create an entirely different character.

1. Draw a circle for the head.

2. Draw a smaller, slightly overlapping circle for the torso. Add a tiny tiara.

3. Now draw the collar of the dress and the "wings" of the sikirt.

4. Add the arms, which are proportionately small, and the hair buns.

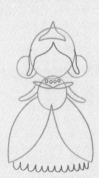

5. Draw in the hair tendrils, the "pearls" and the scallops of the skirt.

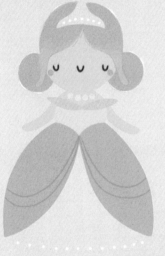

6. Remove any lines you don't need and color your princess using your own choice of palette.

DANCE CLASS

Draw some princesses for these mini princelings to dance with!

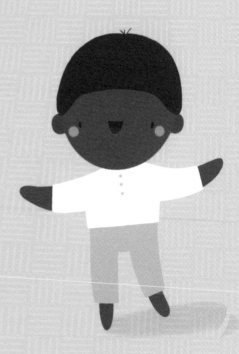

KAWAII HELPFUL ROBOTS

Tiny robots are a perfect kawaii subject. You can vary their body shape depending on what you want them to do. This super-cute robot is just waiting to help out.

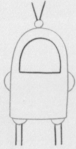

1. First draw a vertical shape that's rounded at the top.

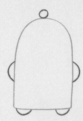

2. Add a tiny circle at the top and shallow half circles on the sides and bottom.

3. Now give your robot a screen, some antennae and narrow "legs."

4. The arms are next: the pose on these shows that the robot is waiting to help.

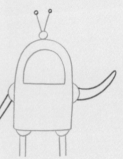

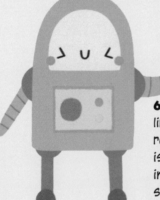

5. Finish off your draft with rounded "feet" and a operation panel.

6. Remove your working lines and colour in your robot. Lots of detail is added at this point, including the on/off switches, lines to indicate how the arms bend, and the ends of the antennae.

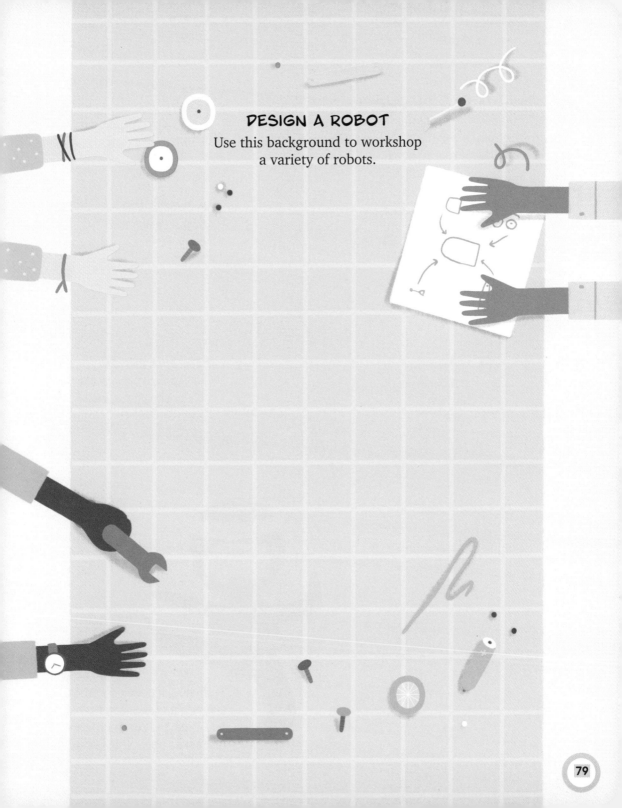

DESIGN A ROBOT

Use this background to workshop
a variety of robots.

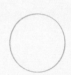

KAWAII LITTLE NINJA

"Ninja" means "one who sneaks" or "one who is invisible."
They're renowned for their ability to move silently and infiltrate
anywhere without disturbance.

1. Draw a circle for the head.

2. Draw a smaller, slightly elongated circle for the torso.

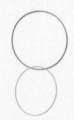

3. Add the legs in a dynamic "kicking" pose.

4. The arms and the unmasked part of the face are drawn next.

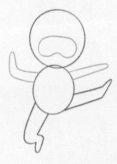

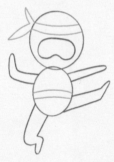

5. Add a belt and a headband to your ninja.

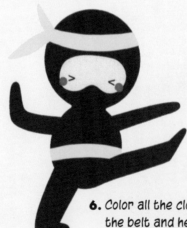

6. Color all the clothing except the belt and headband in black. Add eyes and cheeks to the unmasked part of the face.

ACROSS THE ROOFTOPS

Draw a series of ninjas doing their moves across these rooftops.

KAWAII MINI MONSTER

This is a super cuddly kawaii monster. The technique used here can be adapted to make any shape or size of monster—just use your imagination.

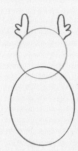

1. Draw a circle for the head.

2. The body is a large, slightly overlapping circle. Draw some horns on the head.

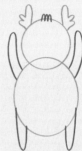

3. Add the arms and legs: this monster looks a bit playful.

4. Remove your working lines and color your monster. This kind of kawaii monster works well in a variety of pastel shades.

Crazy creatures

Monsters come in all shapes and sizes. Here are some different ones to inspire you.

MONSTERS ON THE MOVE

Create a series of monsters to populate the landscape.

KAWAII GOOFY GHOST

Little spooks and tiny ghouls are perfect for the kawaii treatment.
You can make them in any shape you like and they can be super
cuddly or a little bit scary.

1. Draw a slightly tilted circle for the basis of the body.

2. Give your ghost a pointed tail.

3. Add in the arms. They can be in any position you want.

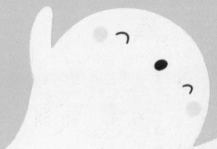

4. Fill in the body color and add facial features to give your ghost its own personality.

Say "boo!"
There are endless possibilities for ghostly kawaii faces..

HAUNTED HOUSE

Add lots of different-shaped ghosts to haunt the rooms of the house. They can be hiding everywhere: behind the furniture, under the beds, and even in the trees.

PRACTICE

Use these pages to practice drawing
your own imaginary characters.

PRACTICE

PRACTICE

PRACTICE

PRACTICE

PRACTICE

KAWAII CHIBI CITY

KAWAII CHIRPY CHEF

Complete with neckerchief, chef's whites, and a classic toque (chef's hat), this cheery little guy is ready to whip up some delicious food. Vary the color of his outfit and the food he serves.

 1. Draw a circle for the head.

 2. Create the base of the hat and the body of the jacket.

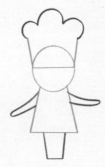 **3.** Add the curves at the top of the hat, his arms, and legs.

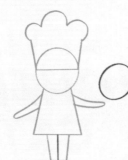 **4.** Draw a line between the legs to show separation and add an oval shape for the frying pan base.

 5. Finally draw in the ears, the frying pan handle, and the chef's feet.

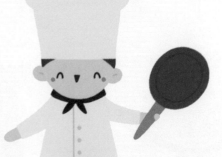

6. Remove any lines you no longer need and color your chef. Give him a cheerful expression and add buttons to his white jacket.

KAWAII KITCHEN

Draw lots of chefs, each busy with their own speciality.

KAWAII CITY MAYOR

Mayors have different functions in different cities. Sometimes it is a largely ceremonial role; at other times they can drive policy in local government and have far more impact.

1. Draw a circle for the head.

2. The top of the body is formed from a smaller circle (not overlapping).

3. Add in her mass of curly hair and the outline of her skirt.

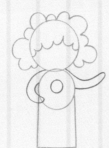

4. Draw her arms, and the pendant of her chain of office.

5. Finally add the chain of her regalia and her legs.

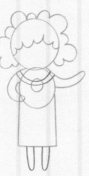

6. Color in your city mayor, choosing strong colors to make her stand out. Add the extra detail on the skirt and chain.

SPEECH TIME

Draw your own version of a mayor taking the podium here.

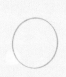

KAWAII BASEBALL PLAYER

This super-cute baseball batsman is dressed in a classic team strip, complete with striped baseball knickers, a traditional ball cap, and a tucked-in shirt.

1. Draw a circle for the head.

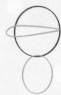

2. Make a much smaller circle for the torso and draw the peak of the ball cap.

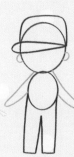

3. Add the outline of the cap and the baseball knickers.

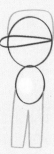

4. Draw in his arms and his ears.

5. Now add his feet and a large, chunky baseball cap.

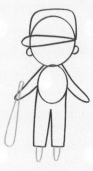

6. Remove any unwanted lines and add color to your batsman. Add details like the stripes on the knickers and the darker pocket and ball cap peak.

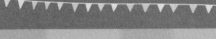

HOME RUN

Add a pitcher to bowl, and members of the fielding team, to stop him getting a run.

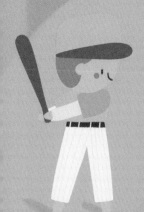

KAWAII AMAZING ASTRONAUT

Even a spaceman (or, as here, a woman), can be drawn in kawaii style. The roundness of the helmet and padded space suit give the figure a doll-like appearance.

1. Draw a large circle for the helmet.

2. The body is a much smaller circle. Draw the face as seen beneath the hair.

3. Add arms and legs, making them more substantial and rounded than on most kawaii figures.

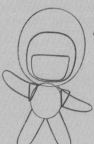

4. Draw the outline of the hair and the shoulder straps.

5. Finish with the detail of the hair and the feed port covers at the sides of the helmet.

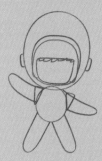

6. Remove any unwanted lines and color your astronaut, adding details such as the badge and lines to represent the joins between the gloves and boots.

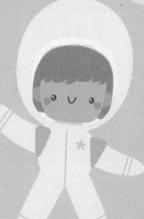

In orbit
Add some stars, planets, and rocket ships to your outer-space scene.

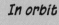

SPACE EXPLORER

Ensure this little astronaut is not alone in
the galaxy by drawing her some companions.

KAWAII PIZZA DELIVERY

Pizza has become one of the most popular home delivery options, bringing fresh, hot, and delicious food swiftly to your door. Create your own delivery guy complete with a mouthwatering pizza.

1. Draw a circle for the head.

2. The torso should be a slightly smaller, elongated oval. Draw the cap peak.

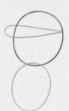

3. Draw the crown of the cap and the legs.

4. Add the arms, one ear, and the feet.

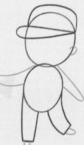

5. Now draw the pizza box, his badge, and the feet.

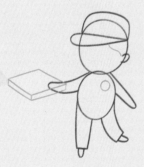

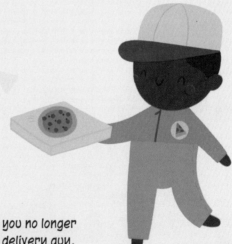

6. Remove any lines you no longer need and color your delivery guy. Choose colors for his uniform that reflect the colors of the pizza.

PIZZA EN ROUTE

Draw lots of pizza delivery couriers on their mission to feed everyone fast.

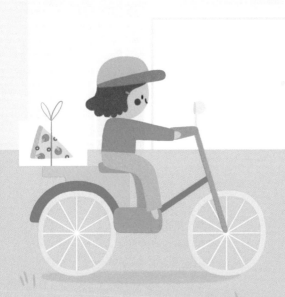

KAWAII BUSY BUILDER

We haven't shown many profiles on our kawaii figures up to now. The head of the builder is seen from the side so you'll have to create the shape of the nose and the laughing mouth.

1. Draw a circle for the head.

2. Create the shape of the overalls and sketch in the brim of the helmet.

3. Add the crown of the helmet, the arms and the line between the legs.

4. Next draw the ponytain and the ridge of the helmet.

5. Finally, make the shape of the nose and mouth. Draw in the tool belt and the feet. Show how the hair goes over the ear.

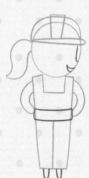

6. Get rid of any lines you no longer need and color your builder. Add detail like the pockets on the tool belt, buttons on the overalls, and ridges on the helmet.

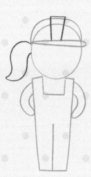

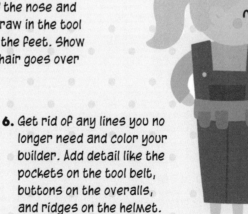

TRICKS OF THE TRADE

It takes many on site to keep a build going.
Give this one some helpful colleagues.

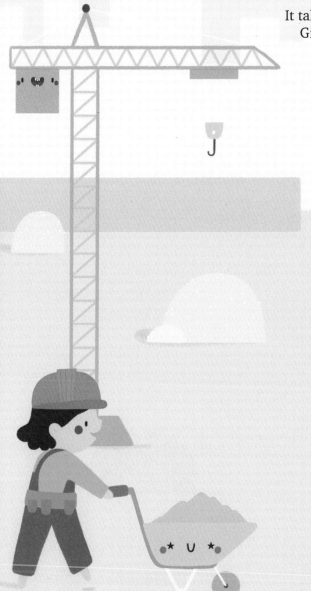

KAWAII RACING DRIVER

Motor racing is one of the most exciting sports around, requiring the skill of the drivers to make their high spec vehicles overtake their competitors. Make sure your kawaii driver is a champ.

 1. Draw a circle for the head.

2. The body is a smaller, overlapping circle.

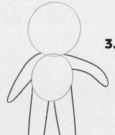 **3.** Add in the arms and the trousers.

4. Draw the helmet under the arm and the feet.

5. Finish your sketch with the hair and the clear visor on the helmet.

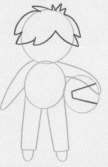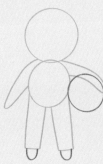

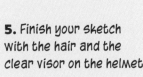 **6.** Remove any lines you no longer need and add color to your driver, including details like the lines of the driver's jumpsuit, and stripes on the helmet.

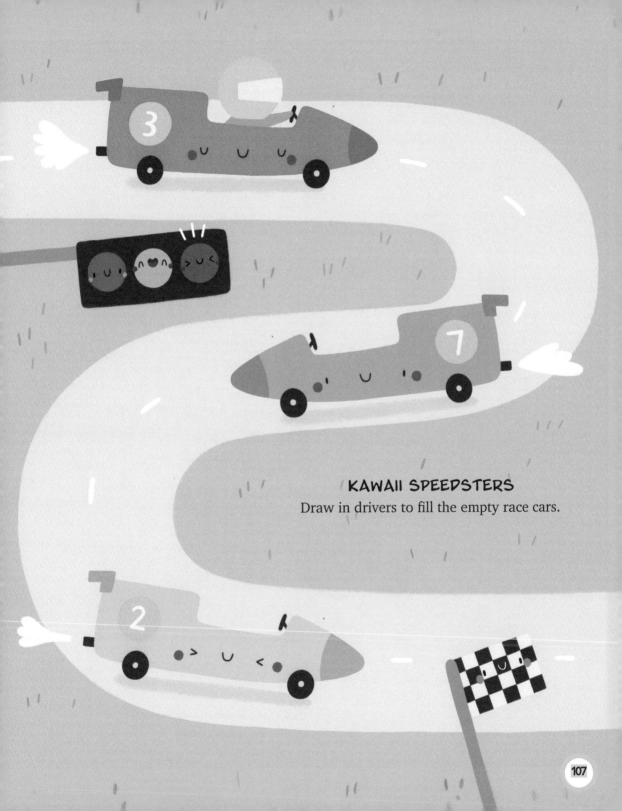

KAWAII SPEEDSTERS

Draw in drivers to fill the empty race cars.

KAWAII KIND NURSE

Depending on where you live, nurses wear quite different uniforms. The kind nurse pictured here has a traditional dress and apron but she could wear scrubs or trousers too.

1. Draw a circle for the head.

2. The torso is a smaller circle. Draw in the cap shape now.

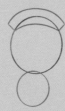

3. Now draw in the arms.

4. Add a bell-shaped skirt.

First aid kit

Draw your nurses the kit to help them help others.

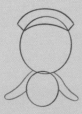

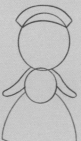

5. Draw in her hair bun, her feet, and the heart monitor.

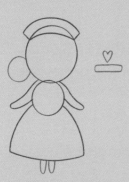

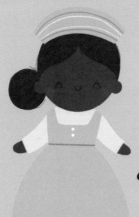

6. Remove any now unwanted lines and color in. The color scheme can be anything you choose.

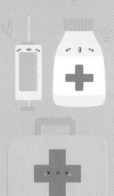

KAWAII WARD

Draw one or two nurses to help get this poor patient better.

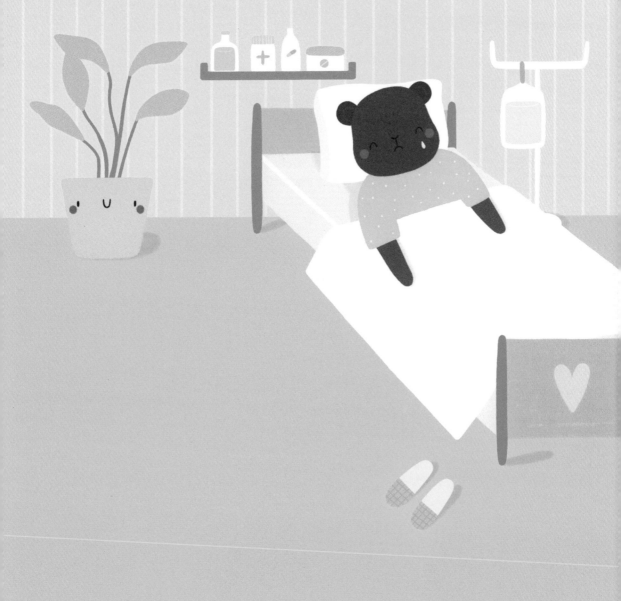

KAWAII SINGING STAR

A singer on stage gives you an opportunity to draw some really fancy costumes and hairstyles. You can go as wild as you like—try extreme colours and extravagant styling.

1. Draw a large circle for the head.

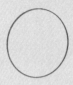

2. The torso is a much smaller, slightly overlapping circle.

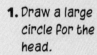

3. Draw the arms and the outline of the trousers.

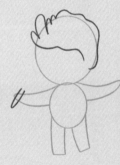

4. Now create his hairstyle. It can be as outrageous as you like. Draw him a microphone.

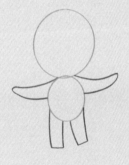

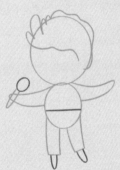

5. Add the bulb of the microphone, the line between top and trousers, and his feet.

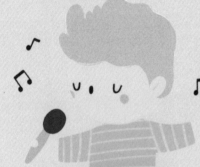

6. Remove any lines you no longer need and color your singer. Add details such as the stripes on his jumpher and musical notes.

ALL THE WORLD'S A STAGE

Create your own rock star to draw a crowd.

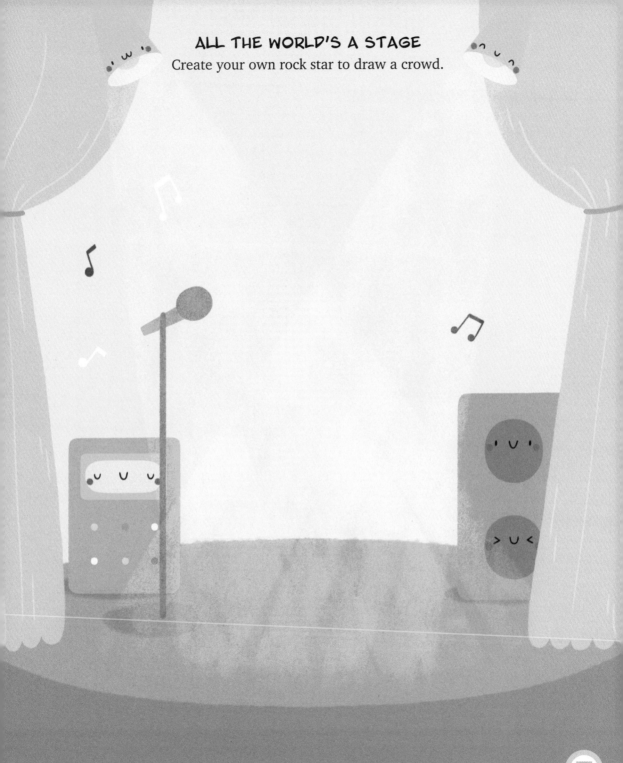

KAWAII FRIENDLY FARMER

In the farmyard and fields, he tends his crops and animals attired in denim overalls, rubber boots, and a straw hat to keep off the sun. You could give him a tractor to help him with his chores.

1. Draw a circle for the head.

2. The line of the hat on the face is added next and a smaller circle for the body.

3. Next, draw the hat brim and the arms.

4. Add the crown of the hat, the legs, and the blade of the spade.

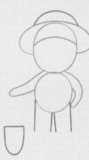

5. Draw the rubber boots and the handle of the spade.

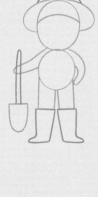

6. Remove any lines you don't need and color your farmer. You can vary the line of the hair and his facial expression.

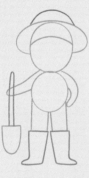

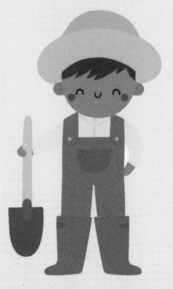

ON THE FARM

Add a farmer and some other
animals to the farm scene.

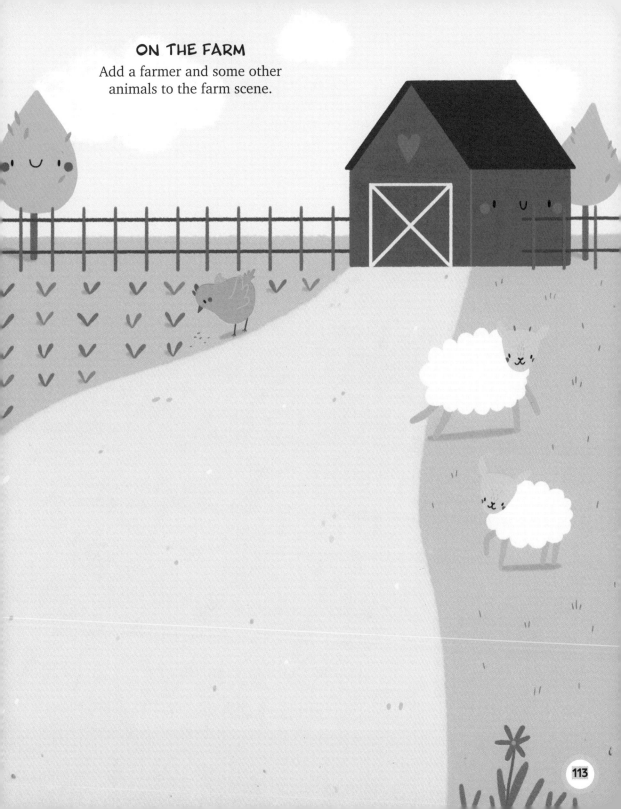

PRACTICE

Use these pages to create your own chibi
characters and populate their world.

PRACTICE

PRACTICE

PRACTICE

JOBS TO DO

There are lots of jobs to do in the city.
Here are some uniforms and tools for you to copy.

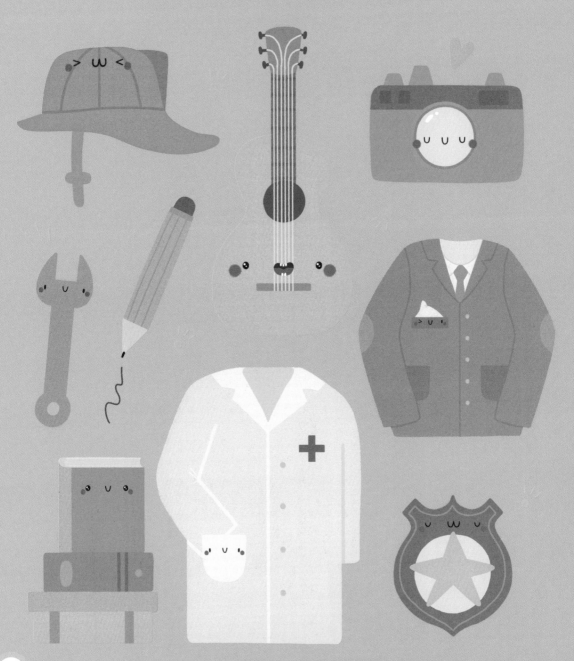

WONDERFUL WORLD

Your kawaii people need somewhere to live!
Here are some doodles you can add to your city scenes.

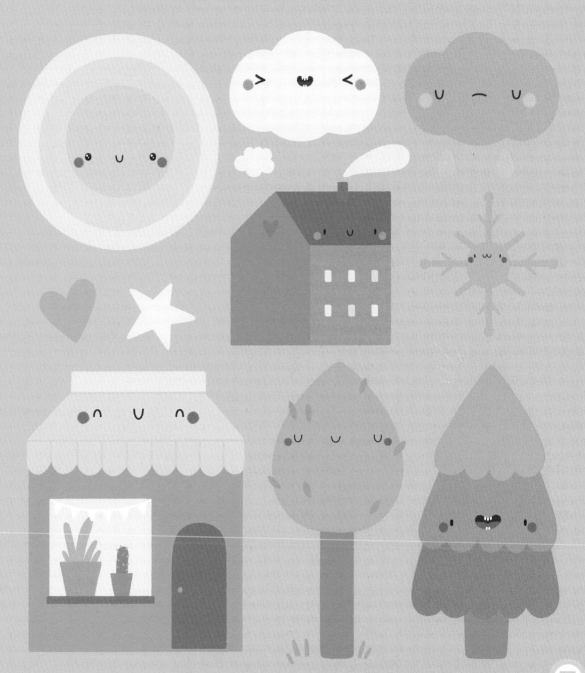

SUPER CITY

Now doodle your own super-cute city.
We've made a start for you.

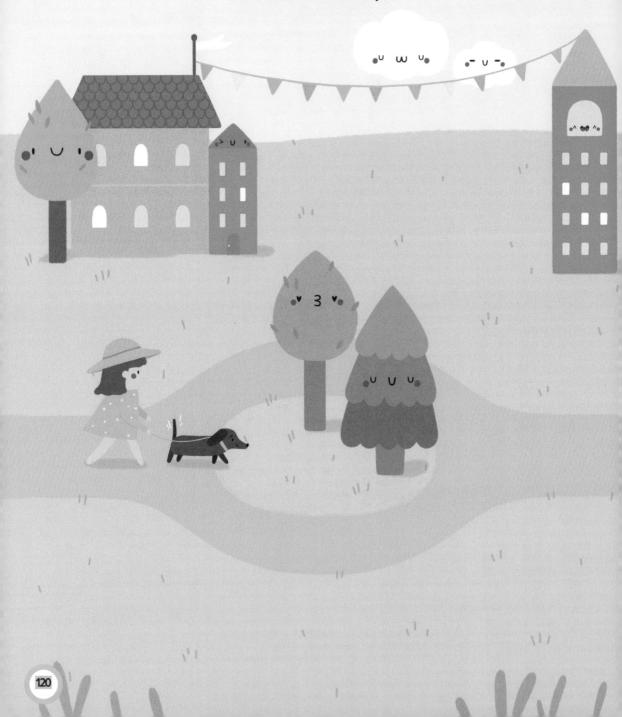

PRACTICE

PRACTICE

PRACTICE

PRACTICE

PRACTICE